The Spirit of the Hebrides

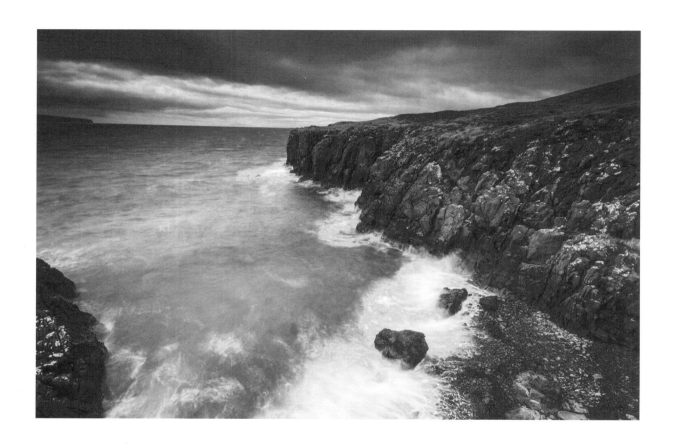

The Spirit of the Hebrides

Images and words inspired by Sorley Maclean

Alastair Jackson
and
Kenneth Steven

SAINT ANDREW PRESS
Edinburgh

First published in 2019 by
SAINT ANDREW PRESS
121 George Street
Edinburgh EH2 4YN

Copyright © Alastair Jackson and Kenneth Steven 2019
Photographs © Alastair Jackson 2019

ISBN 978-0-86153-011-3

British Library Cataloguing in Publication Data

A catalogue record for this book is available from the British Library.

It is the publisher's policy to only use papers that are natural and recyclable and that have been manufactured from timber grown in renewable, properly managed forests. All of the manufacturing processes of the papers are expected to conform to the environmental regulations of the country of origin.

Typeset by Regent Typesetting Ltd

Printed and bound in the United Kingdom by Ashford Colour Press

Contents

Foreword

by Cailean Maclean

This collaboration between Alastair Jackson and Kenneth Steven is to be welcomed for many reasons. For one, *The Spirit of the Hebrides* is the culmination of a successful joint exhibition they staged in St Andrews and Portree a couple of years ago and many at the time regretted that there was no accompanying publication. Happily *The Spirit of the Hebrides* has now appeared and any perceived delay will have done little or nothing to diminish its impact. Anyone browsing the pages of this book will surely realise that the work of Alastair and of Kenneth go beautifully together, the one enhancing the other. Alastair's monochromatic images capture Skye and Raasay deftly and with great sensitivity. His work is singular and incidentally provides an effective antidote to the types of image on social media that send all but the more intrepid visitor scurrying to five or six of the island's *must-see* attractions, and to little beyond them. Alastair's images remind us that there is much of beauty and diversity in places that rarely feature on tourists' Skye tick lists. Skye-born with an island pedigree stretching back to when Vikings held sway in the area, Alastair left Skye more than a quarter of a century ago for further education and, as it so often happens, for subsequent employment. He returns home frequently and perhaps therein lies the strength of his photography. He has a sensitivity and empathy for the subject matter that comes with his upbringing but he also brings a fresher and more urgent eye to his craft than the resident snapper who might tend to be lulled by familiarity with scenes into a sort of photographic complacency. And yes, I speak for myself here.

The images in *The Spirit of the Hebrides* combine pleasingly with Kenneth's evocative poetry, another reason why we should hansel this publication. Kenneth Steven is well acquainted with the Hebrides and has chosen to make his home here. There is an alluring texture and feeling throughout Kenneth's work that can only come from one who has experienced the Hebrides in all their moods, their loveliness and their ugliness. Perhaps Kenneth's own words from his poem 'Hebrides' encapsulate the essence of this book:

This shattered place, this place of fragments,
A play of wind and sea and light,
Shifting always, becoming and diminishing;

These are words that evoke pictures of land and sea scapes changing with the weather and seasons, places with an agitated past and an uncertain future, and people rich in language and culture though not necessarily endowed with material wealth. Kenneth's words lead you to Alastair's images, and the images take you inexorably back to his words.

Ironically enough, it was as a poet I first came across Alastair. I managed to get a copy of his book of verse entitled *Haiku* shortly after its appearance in 2001. If there is any regret that he did not pursue that craft much further it is offset by the fact that ploughing his energies instead into photography has produced so much of aesthetic value. In any case, when there are wordsmiths of Kenneth's stature around, Alastair's migration from poetry to photography was probably a wise move.

This book was inspired by the work of Sorley Maclean. Who can know what Sorley might have thought of *The Spirit of the Hebrides*, but I believe he would be pleased that his inspiration has led to so satisfying a publication.

Introduction to Sorley Maclean

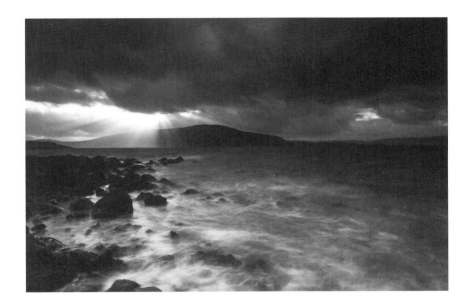

I had been an admirer of the work of Sorley Maclean since my days at Portree High School, when my Gaelic teacher was the redoubtable D. R. MacDonald, his son-in-law. MacDonald introduced us to the works of Sorley, and other Gaelic poets of the twentieth century. But Sorley was the one who stuck in my mind throughout adulthood. A couple of years ago, we were conducting a bit of a clear-out of my grandmother's house, at the behest of a relative,

and I chanced upon a record of Sorley reading his poems at some time during the 1970s. The record was called *Barran agus Asbhuain* (Crops and Stubble), and it turns out that it was the first published recording of his work, released by Dublin based Claddagh Records in 1973. One of the most pleasing aspects of this artefact was the booklet enclosed within the sleeve which contained a transcript in Gaelic and English of all the poems being read.

Playing it, and hearing the sonorous tones of Sorley Maclean, which I had not heard for years, I wondered what the best way might be to somehow pay tribute to his work, in some small way. It always seemed to me fascinating that Maclean mentioned places in Skye and Raasay that I either grew up knowing, or seemed familiar with, the way no other poet did. Sorley Maclean's rise to prominence during the third decade of the twentieth century was unexpected. There had been no truly great Gaelic poets during the nineteenth century, and the early twentieth century provided a backward-looking romantic and sentimental type of poetry that offered nothing new. Sorley Maclean, on the other hand, dealt not only with the political events of the day in his poetry, but with recent Highland history, such as that contained in his great epic poem 'Hallaig', which provided a narrative on the theme of the Highland Clearances, in which Raasay had been delivered a particularly brutal blow. He said himself that his 1939 poem 'The Cuillin' dealt with the 'human condition radiating from the history of Skye and the West Highlands to Europe and what I knew of the rest of the world'. Most poets of the time seemed concerned with places in the Central Belt, or England, or further afield, yet although Maclean could speak of these places, it was his island poetry that seemed to resonate most clearly with me. I began to wonder if I could locate all these island places, and create suitable images to reflect Sorley's words. As these things do sometimes, the idea evolved organically. Kenneth Steven came on board to contribute poems that reflected those places, and suddenly the tribute became arm's length, and I had fewer worries about being able to live up to the standard of Sorley Maclean, as we were now creating work that was inspired by, but independent of, his poetry.

Kenneth had come to my attention through his *Iona* collection of poetry, published in 2000, inspired by the West Coast and Iona in particular. I was struck by how visual his poetry was, a

Highland thing without doubt, and it turns out that his close ancestors were indeed Gaels. In his youth, Kenneth spent much time in the islands of the Hebrides, and in fact now lives on Seil, off the Argyll coast. I think that these things helped us to tune into the project with some depth of feeling, and when I began to visit the places, often with a copy of Sorley's collected poems in my bag, I was able to visualise scenes better. Kenneth understands the link between people and their land; what makes individuals the way they are, and how that identity is shaped and changed by wild places in particular. In some of the poems in this book, he laments the passing of many of the old ways of the Hebrides and especially the dying of the Gaelic. Sorley Maclean himself was concerned about the possibility of a future where nobody was alive to read his Gaelic poetry. However, there is an equally strong thread of celebration as Kenneth explores, in beautifully observed poems, the lives of birds, the beauty of wild places, and the hospitality of the people themselves. Equally of interest to him is the importance of the spiritual within his work, especially that of Celtic Christianity, and its relationship to the Gael and the Highland environment.

While my images are made to be viewed in conjunction with Kenneth's poems, they should not be seen as a literal interpretation, but more as a feeling, metaphorical rather than literal. Maybe, somehow, this captures some of the dreamlike narrative that threads its way through Maclean's best work.

This book project, and the previous exhibition project it sprang from, has enabled and encouraged me to get out and explore some of the wilder and more inaccessible areas of Skye and Raasay, both in good weather and appalling, something Sorley Maclean himself enjoyed doing.

My hope is that together, we have captured some of the spirit of Skye, Raasay and Sorley Maclean in this book and created an artefact that offers a worthy tribute.

Thanks to Kenneth Steven, Cailean Maclean and Saint Andrew Press.

Alastair Jackson

A Word on the Photographic Process

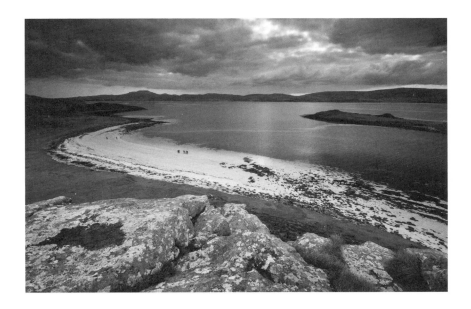

Growing up somewhere like Skye, you don't appreciate your surroundings until you are much older. In many ways this book has been a long circular journey, ending up back where I started. I've tried to identify in this section some of the paths that have led me to being fortunate enough to create images for this book, alongside Kenneth's wonderful, emotive poetry.

During my mid-teens, I made some cursory stabs at making music – or more accurately noise – during school lunchtimes, promptly getting thrown out of the music room by a less than supportive teacher. Although I was competent enough at art in school, I was more interested in things like crushing the still-life fruit displays through the art room printing press than trying to get good marks. Moving on a bit, I had a go at writing some fiction and non-fiction in my twenties – mostly unsatisfactory and underdeveloped, in my view. I even enjoyed a brief brush with the art world in the nineties, thanks to Highland Printmakers, and found myself nailing boiler-suits to the wall among other things.

One thing I enjoyed from my mid-twenties on was hill-walking and getting out into the wilds of the Highlands. I scrambled up and down hills in the mornings and the evenings on my way down to the Central Belt and back up again. I enjoyed summer strolls up the Cairngorms and wild winter days in Drumochter. I marvelled at the hills in Wester Ross which dropped right down to the sea and walked the North Glen Shiel Ridge, swimming in the loch to cool off. I did all this happily for fifteen years, barely taking a single photograph along the way. Occasionally, I would take a notebook to make some notes, or write a description of a hill, but never thought to visually capture any of the wonderful scenery on my expeditions.

It was only in early 2009 that I took a small 'point and shoot' camera with me on a group walk up a snowy Ben Ime near Arrochar. Setting off on a bitterly cold but stunningly clear January morning, we picked our way through deep snow on the upper slopes, as it became obvious that crampons would be needed. The views were superb, and I took a few shots of the guys ahead of me, silhouetted on the skyline. I don't think at that point I realised that every time I went out of the house for the next nine months, I would take that wee camera out, trying to capture colours, light, shapes and shadow.

Since then, that particular camera has been relegated to a drawer, but for me, once I had mastered the basics of photography, by far the most important aspect of making images of the landscape had become familiarity and feeling for an area. This is certainly true in the case of Skye, and to a lesser degree Raasay, where years of walking the hills and coast have given me

an inner sense of the place, which I can translate into my images. The unpredictability of the weather is another factor where it helps if you can make difficult conditions work for you. Sometimes horizons are low, and hillscapes non-existent, so details such as a small part of a shoreline become the focus of composition.

Over the last couple of years, while gathering images for this project, I have made a point of always trying to go off the beaten track where possible. Avoiding the big tourist shots is becoming harder, but by no means impossible on Skye. On Raasay it is still relatively easy. Always ask the question as to why you are taking a particular shot. Putting images into context often saves them from becoming mere decorative wallpaper. Making images for this project has been a real pleasure. Getting out and about in all weathers and all seasons, you begin to realise what huge coastlines these islands have as you tramp up and down cliff edges and through heather and bog. I only made it across to Raasay once during this time, and the weather was absolutely horrendous. I would definitely have liked to have made more images of Raasay as a homage to Sorley, but it was not to be. Those more eagle-eyed may notice that Sleat, the Garden of Skye, is also missing. Again, this was purely down to a lack of time, and I apologise to anyone from that part of the island who may feel offended or disappointed. There is still a lot more of Skye that I intend to explore. Maybe for the next book!

Mòran taing gu Cailean Maclean, Hugh Dan MacLennan, The Sorley Maclean Trust, Arthur Cormack, Ronan Martin and anyone else who has helped in this process.

Alastair Jackson

The Images and Poems

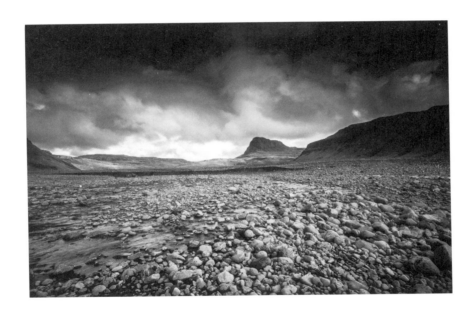

Hallin

On a day the wind comes from everywhere
And the sea is a rugged fleece,
The bell flows over the island
And the black suits and hats go
Slow to the church at the top of the beach.

The psalms lift and fall in long waves,
And after the minister's words are blown away
In the field of stones like broken teeth,
They go back to the warmth of the hall.

The tea is poured like liquid peat into white cups,
And there is talk, the soft water of Gaelic,
As through the advent calendar window
The hill is sugared with snow
And flakes chase the air like birds.

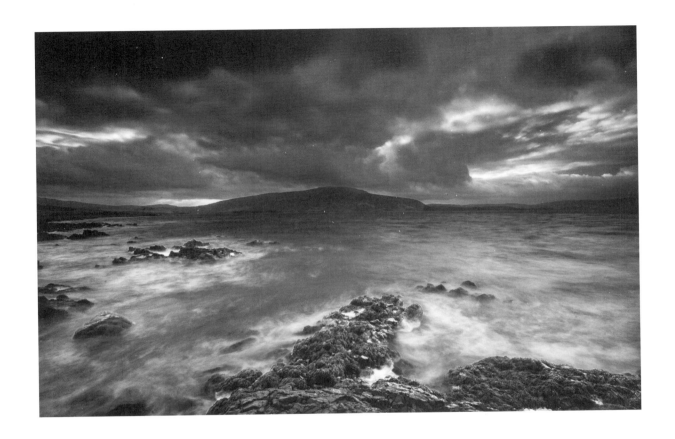

Hebrides

This shattered place, this place of fragments,
A play of wind and sea and light,
Shifting always, becoming and diminishing;
Out of nowhere the full brightness of morning
Blown away, buried and lost.

And yet, if you have faith, if you wait long enough,
There will be the miracle of an otter
Turning water into somersaults;
The jet blackness of a loch brought back to life

But you will take nothing home with you
Save your own changedness,
And this wind that will waken you
Sometimes, all your life, yearning to return.

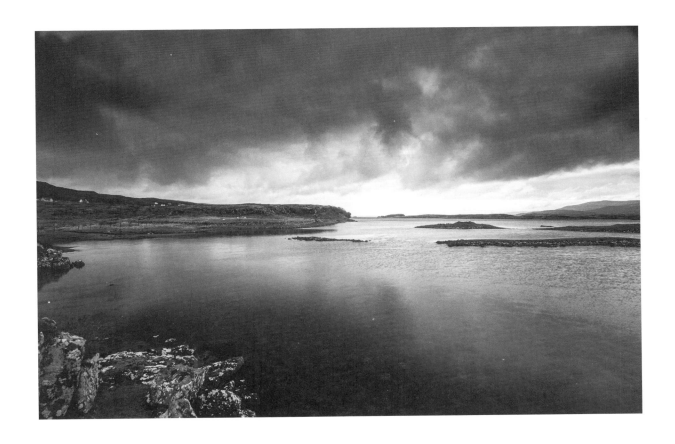

Islands

Even at midsummer the wind is always there
A chasing sky, grass beaten flat,
Gulls bending through torn blue sky,
And somewhere a washing line flapping with clothes
Thrashing the wind, as if waving
To all the ones who left these islands,
Who were blown overseas at the mercy of gales –
The storms of history –
And never returned.

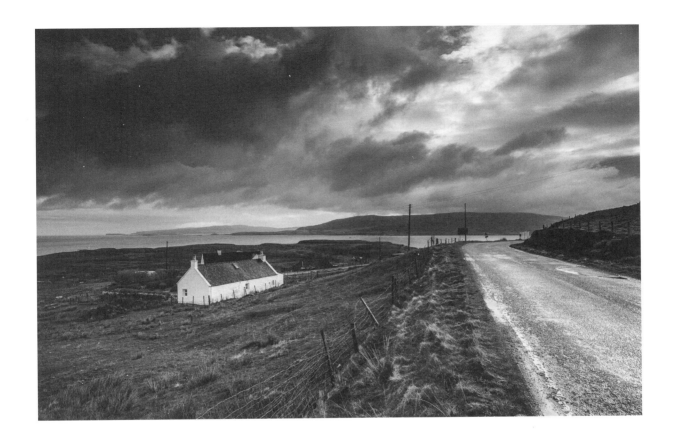

Sometimes

in
all
the
rush
and
hurry
of
our
lives
we
need
so
much
just
now
and
then
to
find
an

island

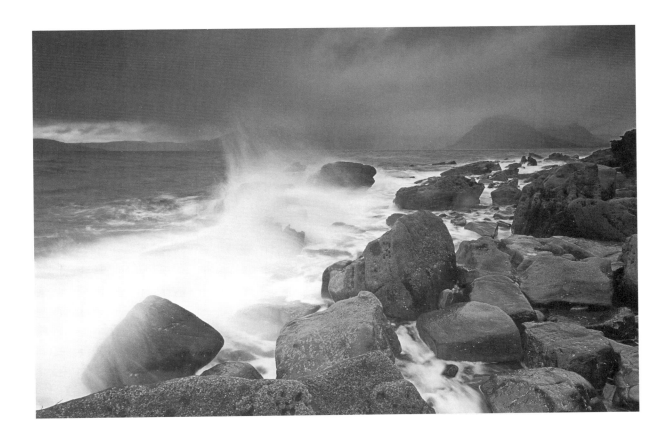

The Music

He got his tunes that way;
He heard them,
As though they were edges of wind,
As if he saw the notes
In the loud rattle of the storm,
In the darkness, coming out of nothing.
He listened for them, as though they
 were bees
In ones and twos to begin with,
Then a swarm, a black net, a mist.
He had to catch them in the bow of his fiddle,
He had to find them before they passed,
Were gone and lost forever.

Where did they come from, those notes?
It was as though they had been sent to
 find him
Through the rampaging of Atlantic gales,
Or else had blown off course
Like a ship's cargo, like a pirate treasure hold,
Had spilled onto St Kilda, into his hands,
Into the fiddle,
Till it was filled brimful.

He wrote none of them down.
He caught them when they came;
He caught them in the net of his listening,
Recognised and remembered them,
Stored them in his head as the others
Stored fish and birds for winter.

They lay in the dark of his head
Like gold in the depths of a cave.
They died with him too
The day his eyes glazed and their light
Failed and faded forever. The tunes were
 blown out
And back into the wind.

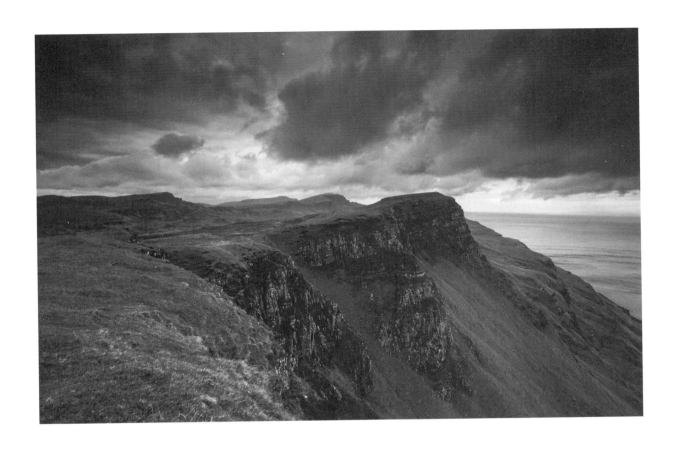

The Words

All night I wrestled with an angel, sure
He carried words that I must make my own
Hour after hour I fought and cried because I could not win,
Because I feared those words would die unknown.
And by the time this morning bled the skies
I'd neither won nor lost, but I could fight no more;
As that first fire of light began to rise
I turned, went out, barefoot, into the dawn
Empty of everything and heard the choir of birds,
And all at once I knew what I should write –
They came alive, they grew – these were my words.

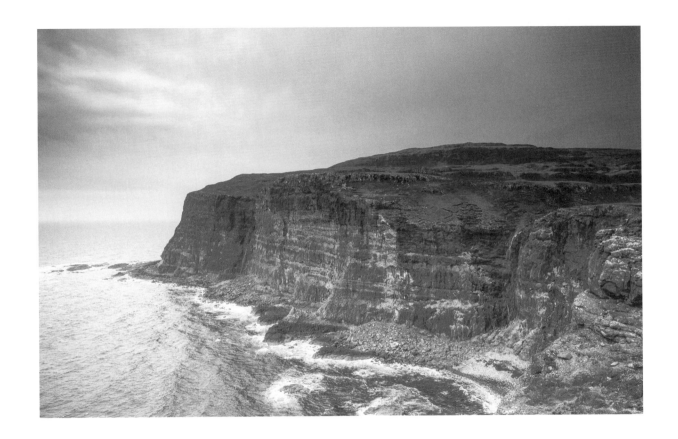

Gaelic

It lies in pockets in the hills
A wink of gold that has not been panned
From the older veins and worn faces.

And sometimes on a dark river of night
I imagine it returning from the seas in its struggle
Like salmon to the birthright of the springs.

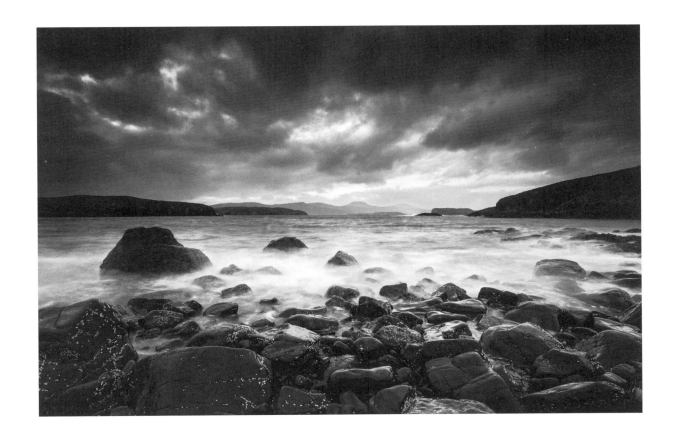

After Culloden

The wounded wandered home in Gaelic
by rivers and back roads
all they had fought for
unsure and broken.

How long before they saw
their language and their land
like a limb that's tied too tight
still there but dying all the time.

Or like a wildcat caught at last
not killed, but tamed;
de-clawed, castrated –
then stroked and told to purr.

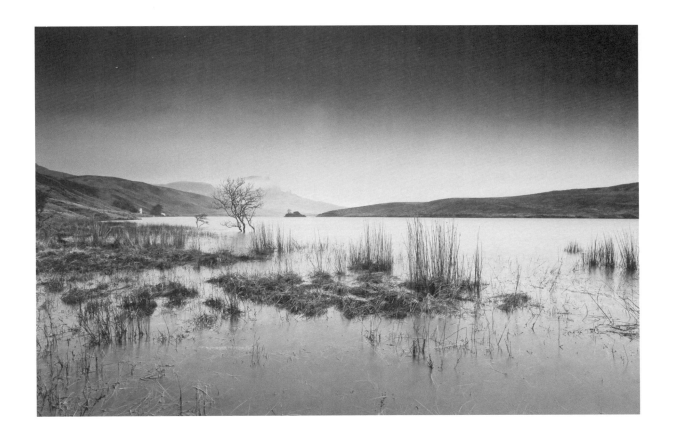

Fire

Through the blurred lens of memory
I see a man
Cutting peats on the bare moon of a moorland.

All the stones that build his world are Gaelic:
Fishing, mending, stories, singing, prayers –
London's out of touch, a blurred voice on the radio.

All day his back bends and the blade shapes
Drenched, dark wedges of peat
That are stacked to dry in the summer wind.

Inside each slab the ferns of Culloden, of clearance,
Of the battle to evict starvation –
Imprints of history like fossils.

This is the peat that lights the memory,
That fires the struggle,
That keeps the heart burning.

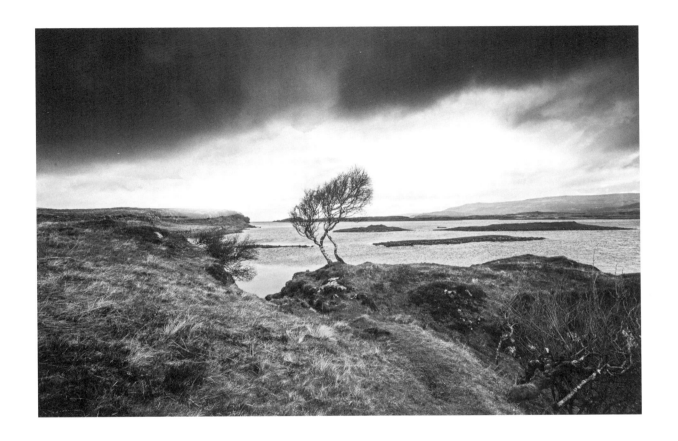

The State of Scotland

See this land through a broken window,
All huddled in mist, rocked by storm,
The whole long drudge of winter.

Half its people want to leave;
The other half who want to stay
Don't choose, they have no choice.

Our history is written in the hills. We are filled
With pride for what we think we did
And guilt for what we didn't do.

We drift into cities since we cannot stand
The sound of our own thoughts. We spend our lives
Being loud, and trying to forget.

Do we want freedom or just the chance
To mourn not having it? We are willing to fight
For all that we don't want.

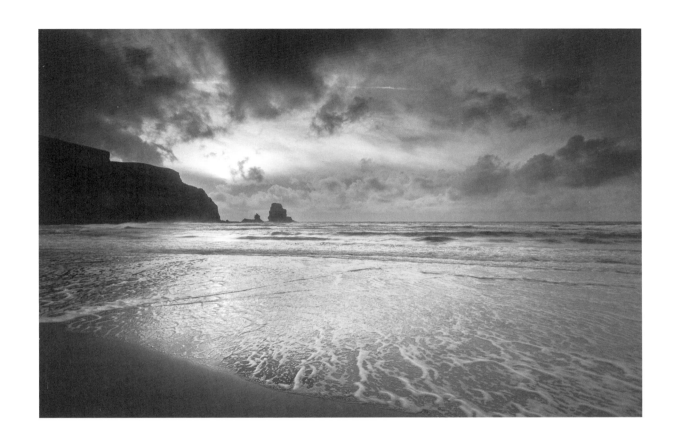

Greshornish

They have all blown away
The ones who knew these hills by name,
Who translated the wind, who spoke
The same language as the curlew.

I remember
The day I came here in childhood
To watch the last of my mother's people buried
Under a weight of memories and snow.

They are replaced by foreign bodies
With Range Rovers and mobile phones
Who smooth the road to London in a day
And do not care.

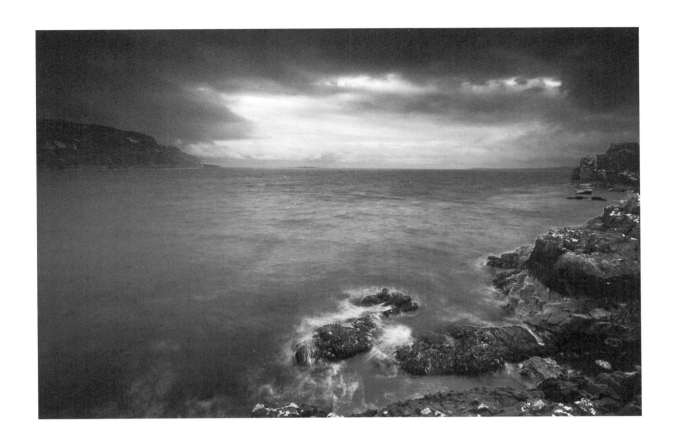

On the West Coast

I have seen them in my mind's eye
Ploughing these rocks for food
Year after year. They live here yet
Though they are dead; long before dawn
They are out at labour along this coast
Bent against wind and sea
Till the last blink of day, till they turn home
To dark rest. They did no evil
All their years, they steered by heaven,
And where was their reward except in bitter winter,
Clearance, grief? They are my fathers,
I carry them in my eyes,
Will not lose sight of them.
Now I come back to this land,
Easy, young, the world in my pocket,
And think still that it is I who am poor,
And they the immeasurably rich.

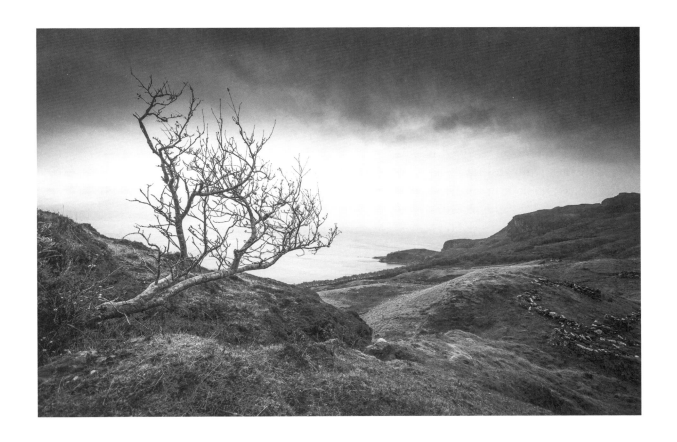

A Different Kind of Light

To climb out of the known
into the moorland's empty miles;
where sun and shadow meet
and the only elements are the ones
that first began this world:
wind and water, rock and light.

You crouch beside the loch,
out of the bullying of the breeze –
and nothing might have changed
since the beginning;
a smear of brightness smiles the water,
before going back to grey.

Somewhere unseen the sadness of a bird –
a single song in the hugeness of the sky,
and suddenly you do not matter
here beyond the normal and the everyday,
the old enslavement of the hours –

you have escaped to breathe
a different kind of light.

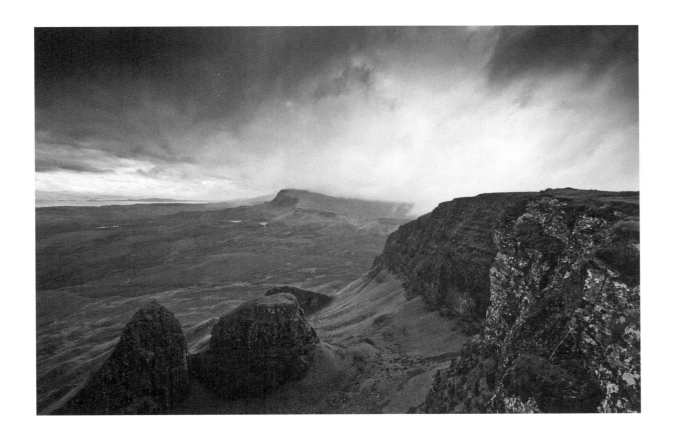

The Summer House

There is the hush of sea in an open window
And a child coming running under bare sunlight
With news of shells and a big whale

There is more time; life slows to a single heartbeat,
The days flow into endless places, stretch like shadows.

The world we carry does not weigh so much;
But seems to fall as simple as a starfish
In something we can see is beautiful again

Sometimes we ride the sea, go out to climb the waves,
To have the laughter knocked from us in play
And come back breathless to a barefoot house
To listen, listen to the late day made of curlews

A huge moon rolls into the sky, ghost white,
Lighting every field, and breeze silks the hills

At night we dream of nothing
Like children who have never learned of sin.

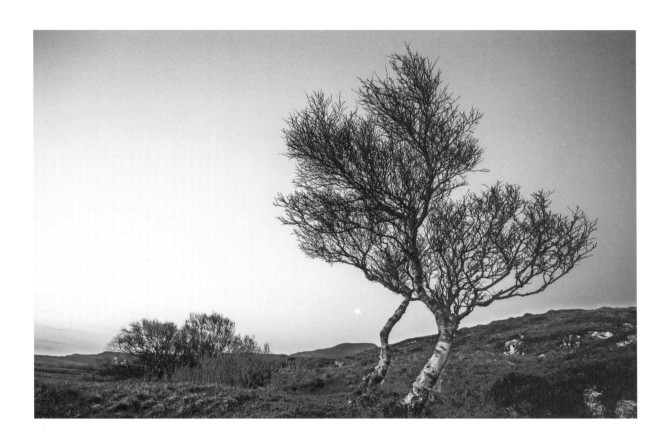

Resolution

After the storm
Blue sky comes back –
A whole field of sunlight

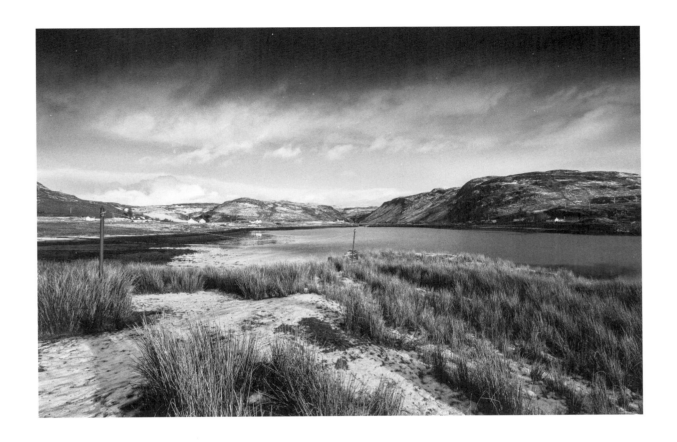

Awakening

A little glen
Opens its winter dark
Into the riches of orchids

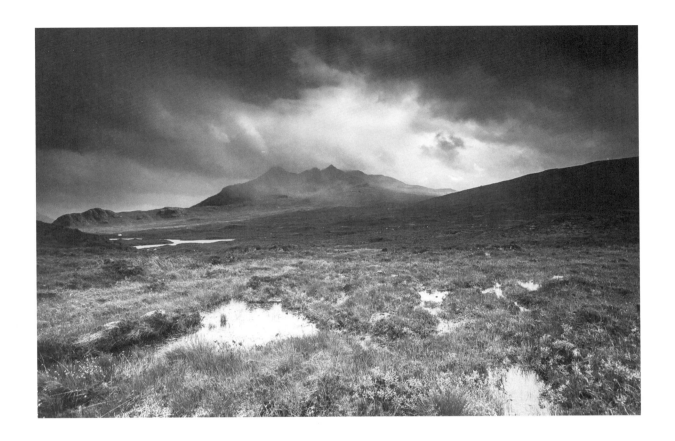

Translucence

There is a beach
Where globes of Baltic amber can be found:
Hold them in the sun like honey

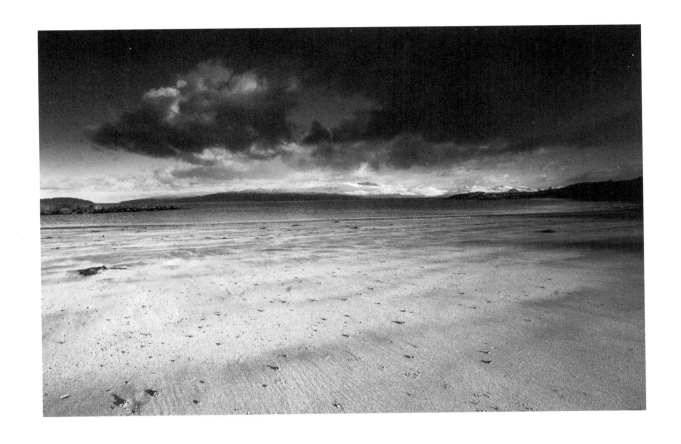

After the Storm

The valley lay in the window
Dazed and damaged
The river horsed under bridges
Swirling with earth and rain.
The fields were filled with mirrors, glass stretches
Reflecting a breaking sky.
The house was silent, left unhumming –
We were powerless; there was nothing we could do.

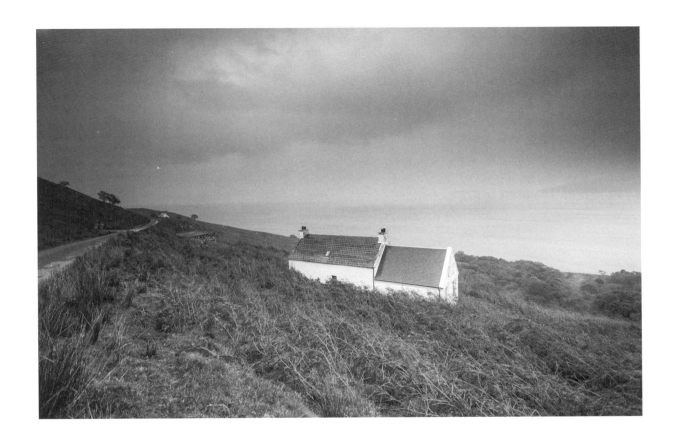

The Search

We have to go so far for silence
Have to row a long way out to listen
Spoon and spoon the water till we dip the oars

Out, above, blue nothingness
An orange edge against the sky
The tips of slow gulls leaving light

Ledges of gold light that change and flash
In this last softening of sun
A rippled mirror all the way across

This somewhere in between the night and day;
Then row slow home, and row slow home
Soundless, leaving the sea unbroken

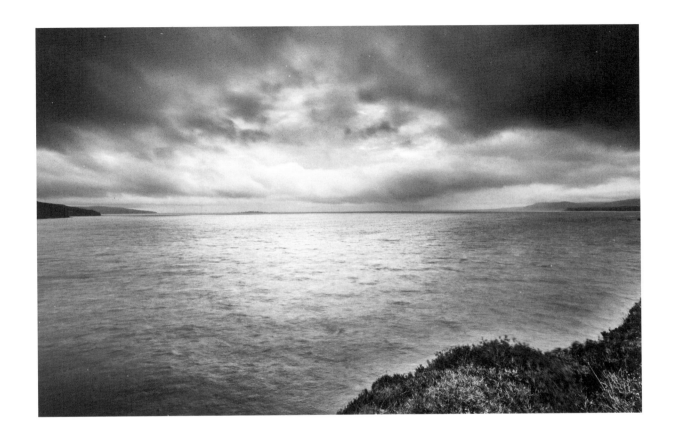

August

A small plane hummed the sky at noon;
Went missing, presumed dead, in the clouds.

When it went dark, purple bruises
Hid among the shrubs and damaged the trees.

A moon tried to climb from the west,
Then broke, spilled quicksilver over silent fields.

A salamander's tongue. Three miles later
The thunder answered like a rousing bear.

The rain. The pure soft song of rain
Silking the whole world, healing the fever.

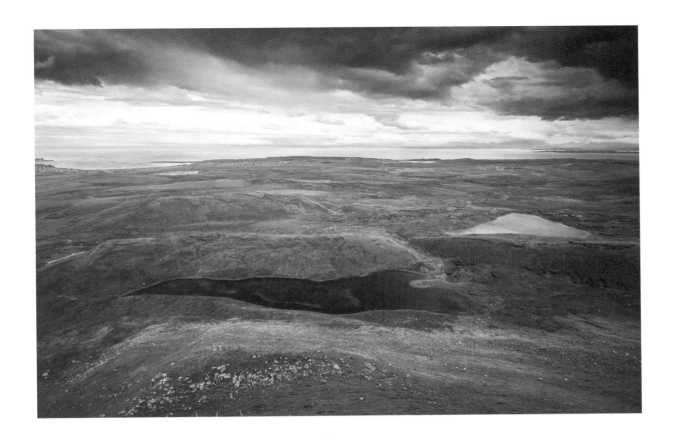

Coracle

A round of dryness, one man strong
Woven and stitched to bob
The slow fishponds and the deeper creeks,
The waterways of crannogs:
Out even to the up and down of sea,
The blue bell of water that does not end,
But reaches, by the compass of the stars –
Another island and a new beginning.

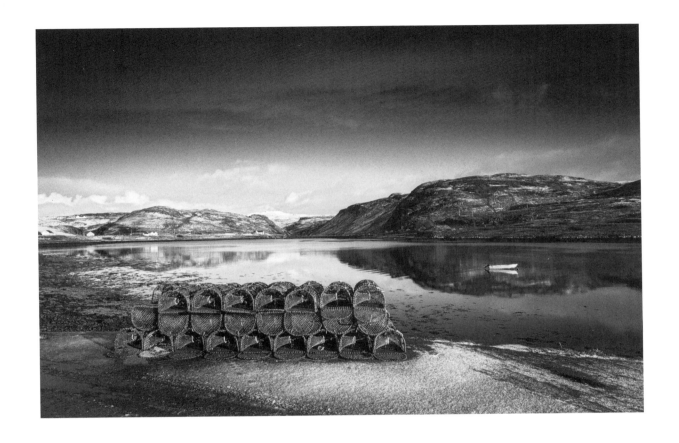

Highland

After a long walk into landscape
Everything went back to being remote:
The loch impossibly blue and a sandy shore
Washed with fragments of wood gnarled to white ghosts.
My mother fished. I hear still the sizzle of the reel
And see the flies blown out on the wind;
How she stood and cast so they danced
On silvering water. I remember chasing
A cloud of damselflies, and red-throated divers –
The ancient echo of their song.
We were above the real world,
Held in the hands of the hills,
And yet this mattered more than motorways –
This place bigger and more real
Than all we'd left behind below:
Undamaged, undisturbed and undenied.

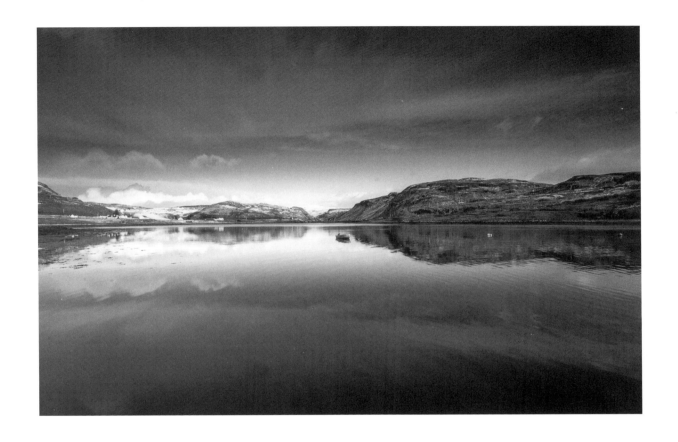

The Ghost Orchid

One day, when the air is sore to breathe
And the seas are dead and heavy, thudding
Over empty shores, and only a dwindling of us

Remain – strange, in hiding,
From yellow and red skies,
From scabbed earth –

We will draw in caves
The eerie shapes
Of everything we remember;

We will weave out of firelight
What fields meant, what horses were,
The story of flowing water, of birds bringing morning into song.

And for a while
Before we have grown old
Like moss on rocks, furred and searching with age,

Our children will believe
It was that beautiful
That good.

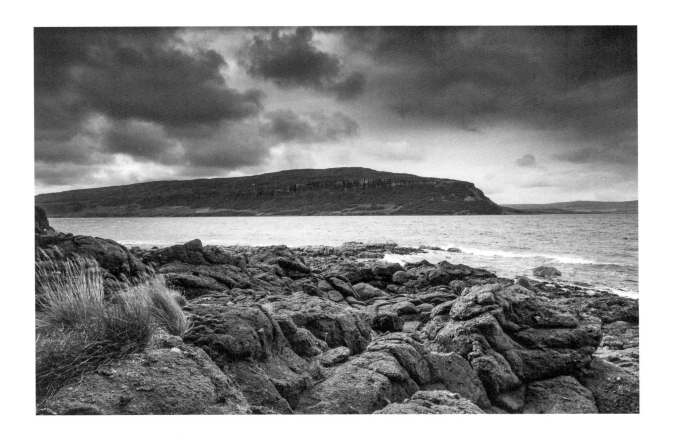

Easter

When the year is beginning again,
The sleet coming in wet cotton on the wind
To build against the dykes;
And sometimes the sun like a single eye
Blind behind the clouds;
And daffodils, the frail green of them
Hidden away and hurting in the wind –
I am no longer full of my own emptiness
But just light and sky, listening
And able to hear at last.

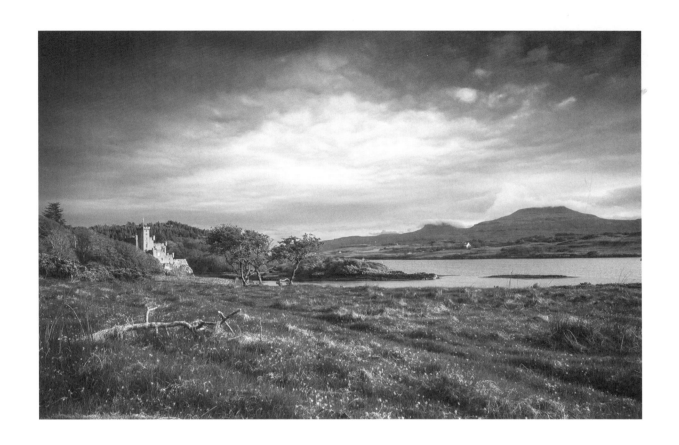

Finding You Gone

A patchwork quilt of fields
Cluttered villages, strung out along roadsides like clamshells
Then another air, the yelping of gulls
And over a hill the whole grey weight of the sea
Unrolling like giant white carpets on a beach.
I walked down, huddled deep in a jacket,
To hide from the gnawing of November cold
That came in longships from the north.
Nothing there but blown away bits of birds
And an empty hugeness. And you hurt me,
The absence of your hand like a knife wound,
Somewhere inside;
The wind and you made soft salt tears on my cheeks.

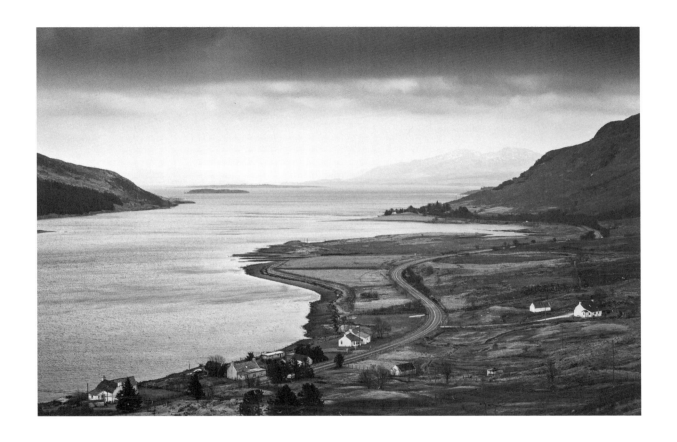

Make Believe

There is no God nowadays,
We have grown up and gone away from home
There is no last prayer before the light goes out –
We lie awake and wonder and the dark is sore.

Sometimes, in the flicker of the dawn,
When the garden blooms and a thatch of birdsong –
We feel the place that joys and hurts
Empty and wanting.

Sometimes, in the suburban sadness of the last train going home –
Acres and acres of living rooms,
Flickering thin November rain
We wish and know it's all too late.

We must understand the murders of children alone now;
We must put back on an old shelf the donkey and stable
We made a long time ago
We have to believe we were wrong.

We need to keep on going
And everything will be just fine
Of course it will – it's only a question of time
Nothing more than a question of time.

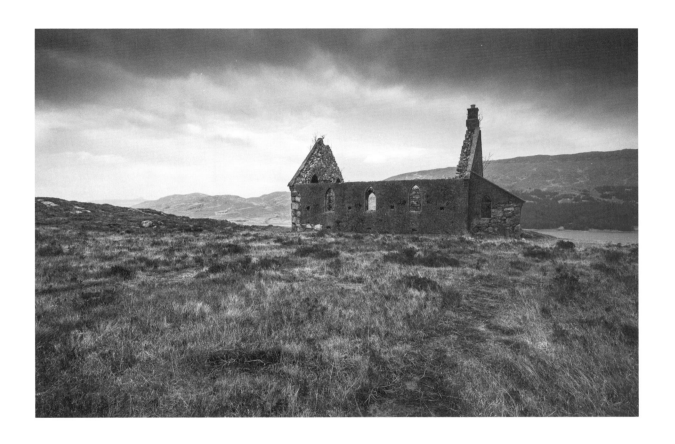

Prayer

If you do not believe in God
Go on a blue spring day across these fields:
Listen to the orchids, race the sea, scent the wind.
Come back and tell me it was all an accident
A collision of blind chance
In the huge emptiness of space.

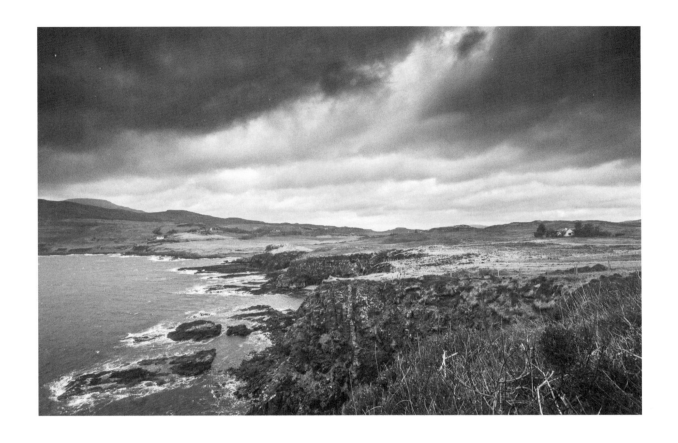

Raasay

And God said:
Let there be a place made of stone
Out off the west of the world,
Roughed by nine months of gale,
Rattled in Atlantic swell.
A place that rouses each Easter
With soft blessings of flowers
And shocks of white shell sand;
A place found only sometimes
By those who have lost their way.

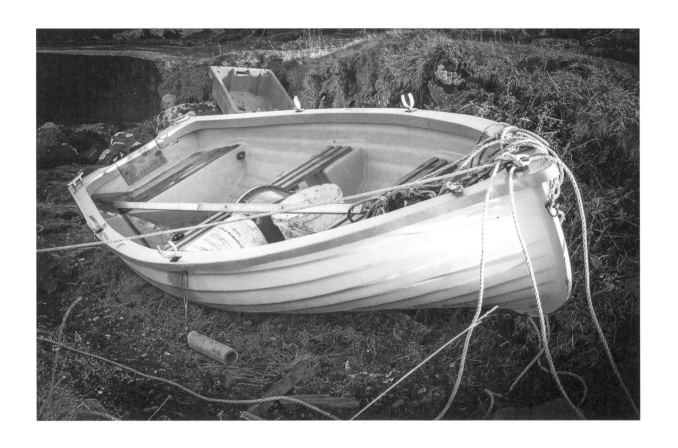

Remember

There will only be a few days like this –
The low sun flinting the house
Through the green sea of the trees as you stand
Struck, blessed, bathed in the same light
That rose life once from the young earth, that applied
The first child's cheeks.
There will only be a few days like this
To stop doing and stand, blinking,
As the leverets tumble in the bright field
And a cuckoo's moss voice calls from a far wood.
Wait until the sun has gone in broken orange
Down beneath the hills, and the blue sky
Hurts with the sudden shudder of the dusk.
Give thanks and turn and go back home –
For there will only be a few days like this.

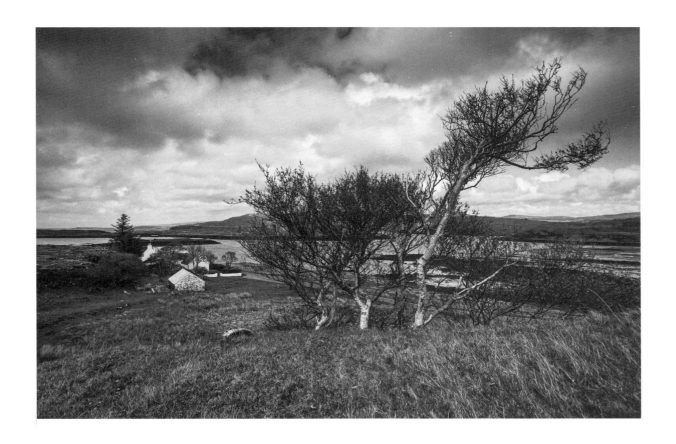

Sonnet in Snow

How do you describe the snow falling
Heavy from a December sky?
There is no sound, there's less than sound;
The birds have gone as though they never were –
The trees wait with their arms outstretched
To fill with strangest shapes of snow.

And when you look across this world
Sky and fields and falling snow are all the same
And yet remain themselves,
Just as my steps across the world are there
Every place I go remembered –
The journey of my life left,
Printed in a pressed shoe.

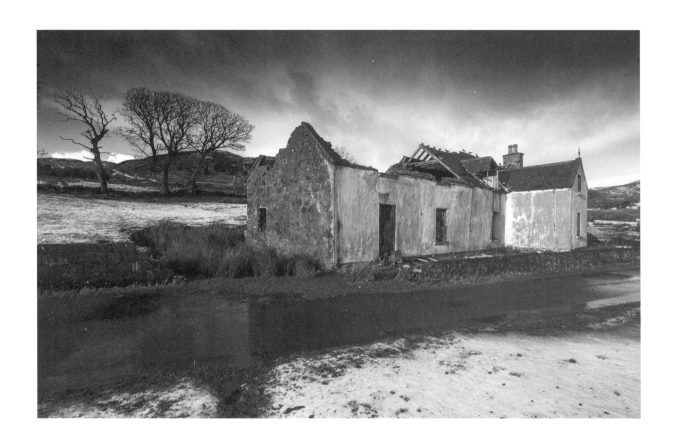

Spring

Out of that battered coast and all the winter can throw
The days of flurrying snow and the wind searching
The long and starless nights, high seas and the power gone
The Spring comes suddenly in the twirling song of a lark
A torn blue sky and the light here and there in fragments
The jewellery of flowers reds and blues and golds
Rising from among the rocks year after faithful year
Can anyone dare to say they do not believe in miracles?

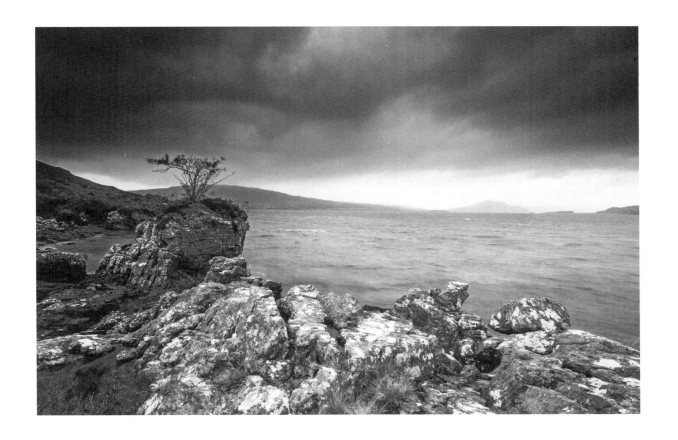

That August Morning

I remember a Summer
The days hung yellow and would not move
And I leaned out at night to thick, warm darkness
The air all made of moths, the trees held breathless

And when the thunder came at last I loved the fear of it;
The flickering that lit the hills, the seconds held,
Before the grumbling and the boom of anger –
The hissing singing of the rain.

I remember that morning after the storm:
I crept the stairs, went out to stand in sun,
Beneath the shadow play of swifts
The whole sky blue, the air left deep and clear.

And whether you believe in God or not,
I did that day, still looking up, eyes closed –
My life in purest light.

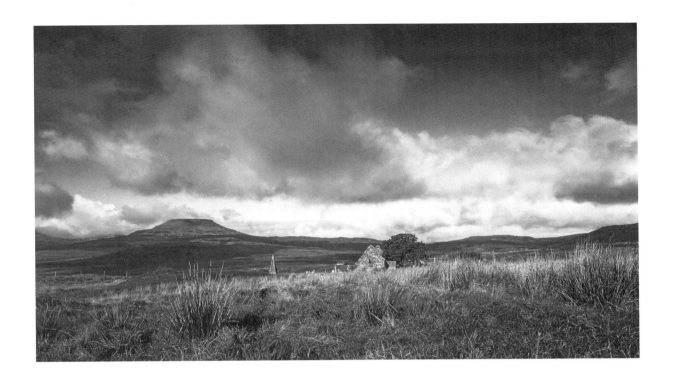

The Drowning

Dawn came
Like the opening of a wound

We went on searching
Long after it was useless

Because going home was worse, because we knew
The sea would pour into our wounds

Drown us also. So we crabbed about the rocks
Our hands like lumpfish,

Our faces wet from the rain's grief.
All I found were pieces of wood

Curved by their years at sea;
All I saw was the swivel of the lighthouse

Far out on the rocks' teeth
A strange white cry in the dark.

When we had walked further
Than our own comprehension, we came home

We listened to the house shifting and tilting
In the wind, we sat and watched the radio

Watched the telephone.
We were our ancestors at last, all we had ever feared.

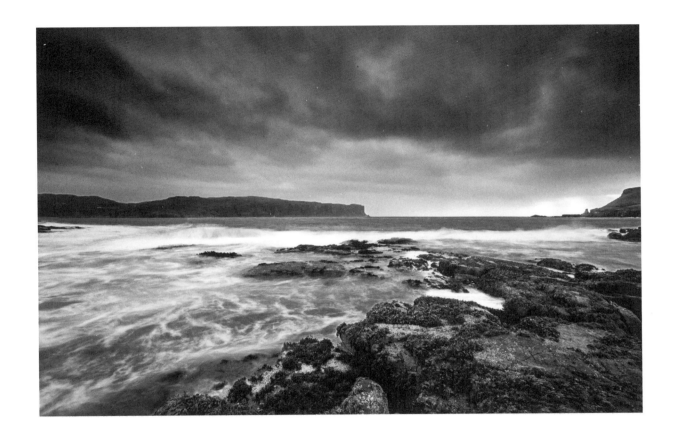

Geese

This morning I caught them
Against the headlands of rain
Glowering in from the west;
Half a hundred twinklings
In the angry sky, a gust of somethings
Grey against the greyness.

And then they turned in one gust
To climb the April sky
North, becoming a sprinkling of snowflakes
Underlit – to rise in a single skein
An arrowhead ploughing the wind.

And I knew them as geese and stood watching
Their homing for Iceland;
I stood in the first splinters of rain
Watching until they were gone
And with them all my winter.

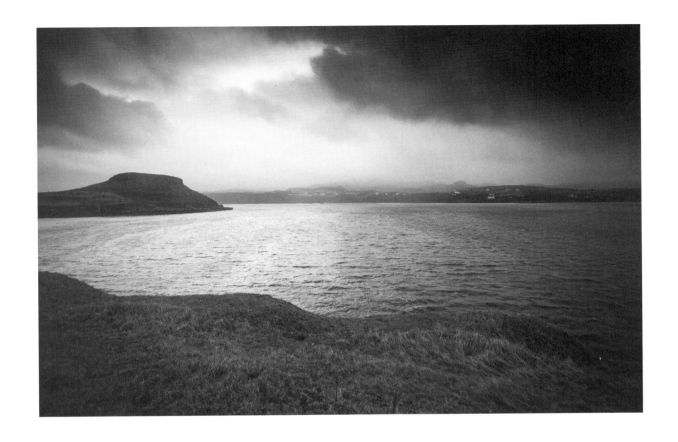

Old Woman

And so she ages by the day
The threads that wove the fabric of her mind
Fray one by one and will not mend.

Once she was beautiful, and knew it,
Once her blood's fire burned in a man's veins
Night after night, and her colours
Enflamed the coals of his heart

Who may see that now,
When the nurses bring her things and swear
Behind her back because she cannot hold
A spoon, or manage the stairs?

Inside her yet, beneath the autumn wrinkled face
She lies, the girl she was; the dreams, the dance, the light,
Not dead, but sleeping, still alive and clear
To those who know to look beneath the skin.

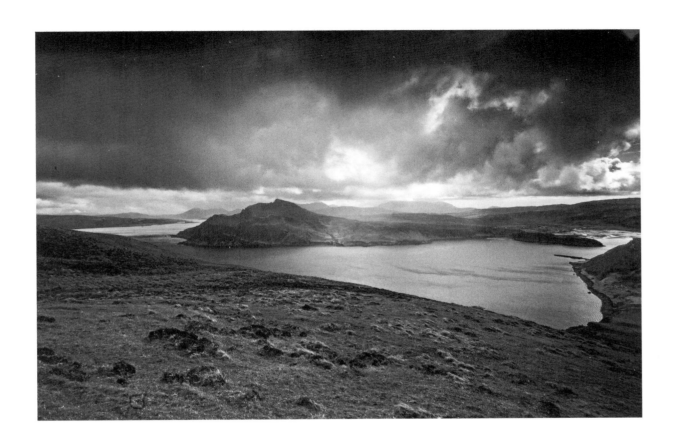

The Black Beach

a ledge of darkness
the sea swivelled
hissed in its rolling
the boat lurched and swung
like thread through the eye of a needle
closer and closer
in to a cut in the cliffs
the stench of birds and wet stone
the rocks a singing of droplets
they crouched, salt-lipped
their mouths dry caves
the dank slap of water
the thick, bad air
and the boat nudged in
dunted a black beach

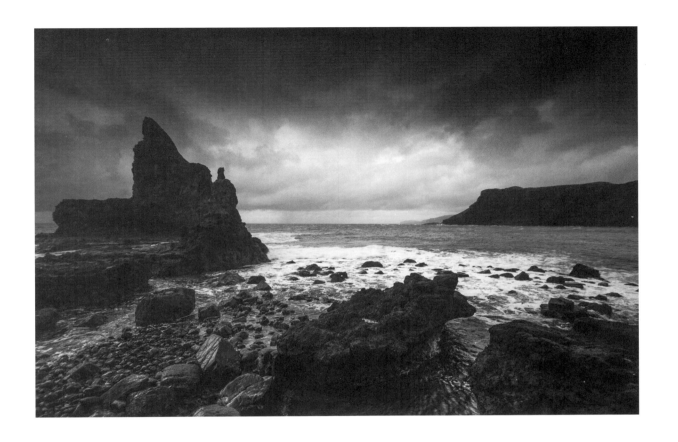

All that I know

The late sun leaving the trees an orange-red
A soft honey fire. There has been no breath of wind
In fifteen days; leaves hang gold and gorgeous
In the woods, and through them deer tread
Patched with light, wary. The year begins to die;
The rowans hang in blood red clutches, every day
The ripe sun is lower in the sky. Is this what it must be?
Or did everything begin to live forever
Before the bite of the apple and the long fall
Into our own demise? Is the worm at the earth's heart
Our fault, the birth of our badness,
Or is it the last blizzard of all things,
The withering of all that is, no more
Than it should be, like a child's blown bubble –
Beautiful to begin, with spinning reds and blues –
Until it fades in a ball of cobwebs, bursts
In a thistledown of drops?
All I know is the seed sleeps December long –
Forgotten, gone, buried in the dark –
And then is born again.

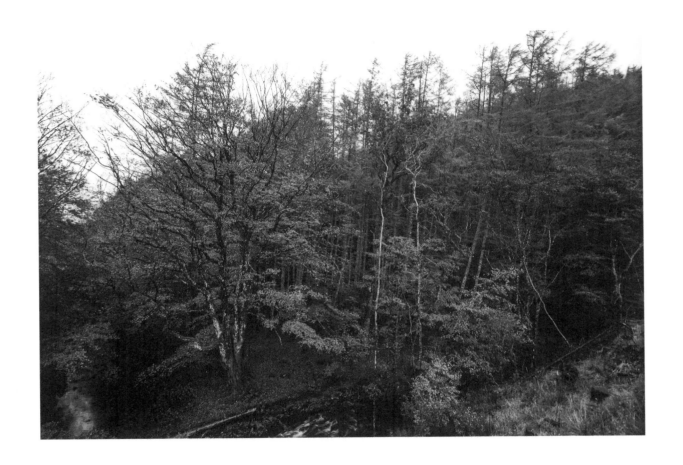

Soldier

I see you now, eighteen,
A blond curl of smile, bird's eggs eyes –
No wrong in you except one motorbike spin
At midnight, when Peter and you came home next morning
Feet awkward and too big, your hands confused.

Now you're going to war;
You stand on the lawn in your uniform
With the cherry trees behind you,
And you don't look a man at all
But a boy in a beautiful play.

What will they do to you there?
What things will you see done on wires
That will haunt you forever?
What things will you do for your country
You never knew were in your hands?

Breathe in this blue wind a last time, boy,
Before you leave, and put this spring day
Deep in the safety of your heart
Like a photograph, to fray and tatter, precious –
For you will not come back again this way.

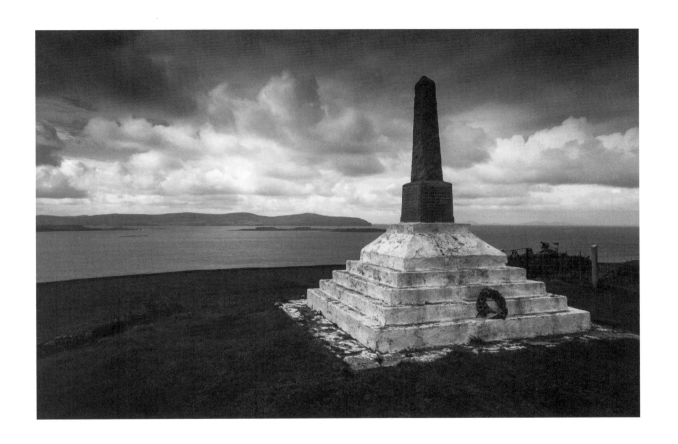

List of Image Locations